CHRISTOPHER HART'S DRAW MANGA NOW!

Top Ten Essentials

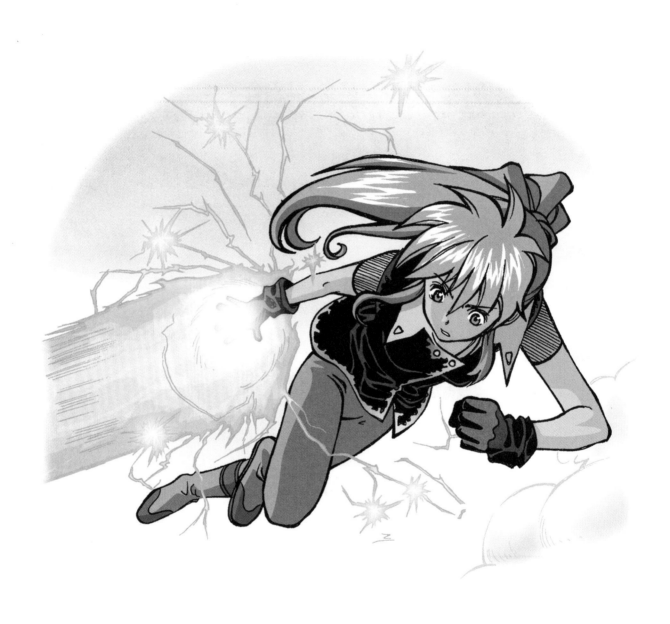

Top Ten Essentials

Christopher Hart

Watson-Guptill Publications
New York

Compilation copyright © 2013 by Christopher Hart, Cartoon Craft LLC, Star Fire LLC, and Art Studio LLC

Published in the United States by Watson-Guptill Publications, an imprint of the Crown Publishing Group, a division of Random House, Inc., New York.

www.crownpublishing.com
www.watsonguptill.com

WATSON-GUPTILL is a registered trademark and the WG and Horse designs are trademarks of Random House, Inc.

This work is based on the following titles by Christopher Hart published by Watson-Guptill Publications, an imprint of the Crown Publishing Group, a division of Random House, Inc.: *Mania Bishoujo*, copyright © 2005 by Christopher Hart; *Manga Mania Chibi and Furry Characters*, copyright © 2006 by Christopher Hart; *Manga Mania Magical Girls and Friends*, copyright © 2006 by Christopher Hart; and *Manga for the Beginner Chibis*, copyright © 2010 by Star Fire LLC.

Library of Congress Cataloging-in-Publication Data
Hart, Christopher, 1957-
 Top ten essentials : Christopher Hart's draw manga now! / Christopher Hart. — First Edition.
 pages cm
1. Comic books, strips, etc.—Japan—Technique. 2. Drawing—Technique.
I. Title.
 NC1764.5.J3H377 2013
 741.5'1—dc23
 2013002121
ISBN 978-0-385-34544-6
eISBN 978-0-385-34541-5

Cover and book design by Ken Crossland
Printed in the United States of America

10 9 8 7 6 5 4 3 2 1
First Edition

Contents

Introduction

Welcome to *Draw Manga Now! Top Ten Essentials.* This book gives you the most common, most important, and most practical techniques used by professional manga artists, shown in short form, so that you can flip to them quickly and easily. It also looks at common trends and character types that appear everywhere in manga, regardless of the genre. I can guarantee that all of the steps and instructions are easy to follow yet still teach you everything you need to know. You might even have some fun along the way! This is the essential crash course in manga that you've been waiting for.

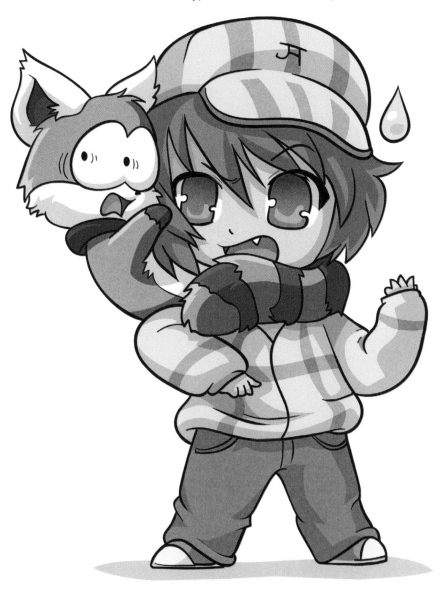

To the Reader

This book may look small, but it's jam-packed with information, artwork, and instruction on the top ten elements that are essential to drawing manga like a master!

We'll start off by diving right in to the relevant specifics you need to know now! Pay close attention; everything builds on these basics. You might want to practice drawing some of the things in this section before moving on to the next one.

Then, it'll be time to pick up your pencil and get to actually drawing complete iconic manga characters! You'll follow my step-by-step illustrations on a separate piece of paper, drawing the characters in this section using everything you've learned so far.

Finally, I'll put you to the test! The last section includes images that are missing some key features. It'll be your job to finish these drawings, giving the characters the elements they need.

This book is all about learning, practicing, and, most important, having fun. Don't be afraid to make mistakes. If you don't make any mistakes, that means you're not attempting to tackle new techniques. In fact, the more mistakes you make, the more you're learning. Also, the examples are meant to be guides; feel free to elaborate and embellish as you wish. Before you know it, you'll be a manga artist in your own right!

Let's begin!

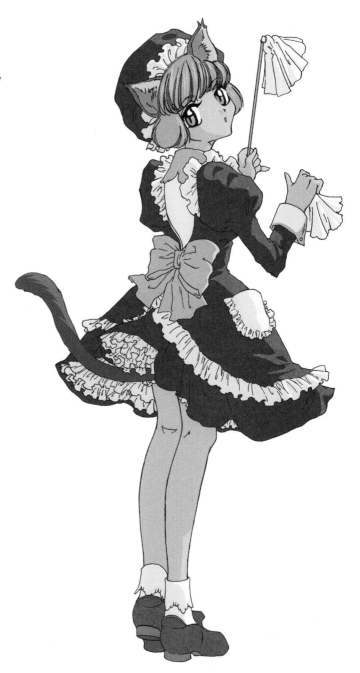

PART ONE
Let's Learn It

#1 Eyes

The eyes are, hands down, the most important and characteristic feature of manga characters, so we'll start with them. Manga characters are, by definition, set up to feature the eyes as the center of focus. Manga eyes are oversized, contrasting with the rest of the facial features, which typically get less detail.

To make the eyeball itself sparkle, you'll need to use contrast. That means you need to draw "shines" amidst heavy pools of black. Shines only sparkle when surrounded by dark areas. But if the dark area is pure black, the shines may end up looking like white spots, not reflective or moist, which is what you're after.

To lay down their eye shines, manga artists use solid black areas with streaked lines that mimic the look of irises. The results are so effective that the eyes seem to almost glitter. This streaked effect—migrating out of the pools of darkness, combined with multiple shines of varying sizes—makes the eyes really pop. In addition, note the natural path that the eyelashes take, as well as the heavy lines of the eyelids.

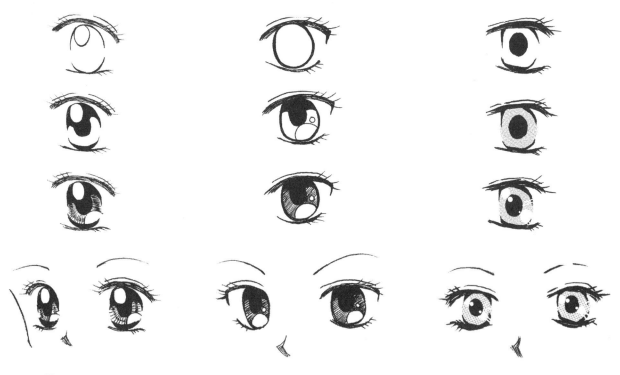

Gentle
- Note the crease lines.
- Basic outline and lashes.
- Fill in the blacks.
- Add streak lines.

Sultry
- Combine small shines with large shines.

Intense
- Tone with highlights.

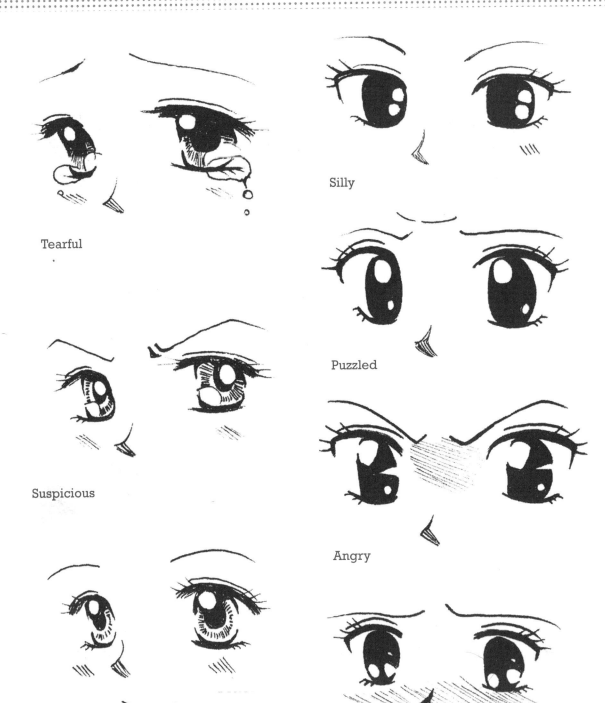

Tearful

Silly

Suspicious

Puzzled

Angry

Encouraged

Hopeless

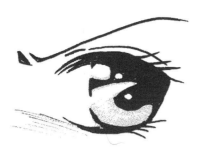
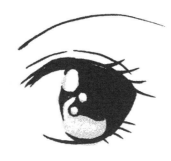
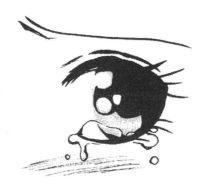

Moist-Eye Variations
Pupils become very large and irregularly shaped. Tears bubble over.

BEAUTIFUL EYEBROWS

Yes, you can draw the eyebrow as a thin, simple arched line. There's nothing wrong with that, and many great characters have simple eyebrows. But why not use some cool variations that make your work stand out? After learning the basics, give some variations a try!

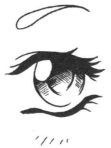
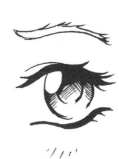

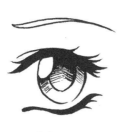
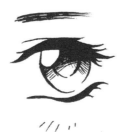
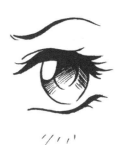

#2 Expressions

The popular expressions of manga show up in all genres and appear on a variety of characters. Therefore, the expressions you see here will apply to many other characters as well. You can practice the faces as they are shown here or try them on other characters, adapting them to make them your own.

Hungry

Hurt

Annoyed

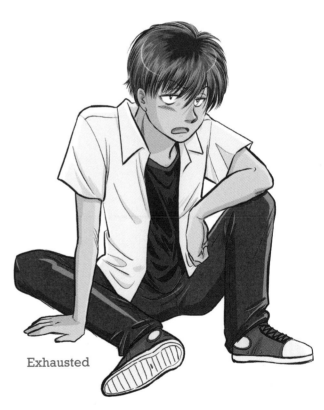

Exhausted

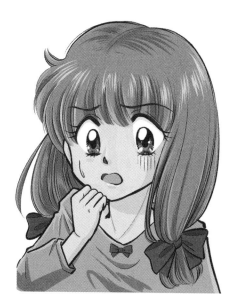

Scared

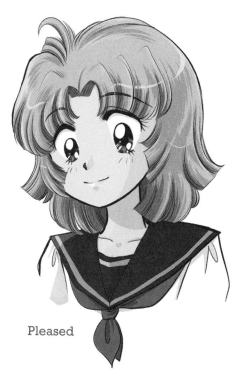

Pleased

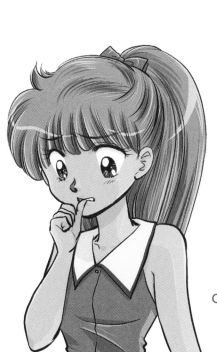

Concerned

Sneaky

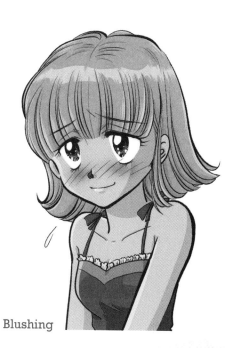

Blushing

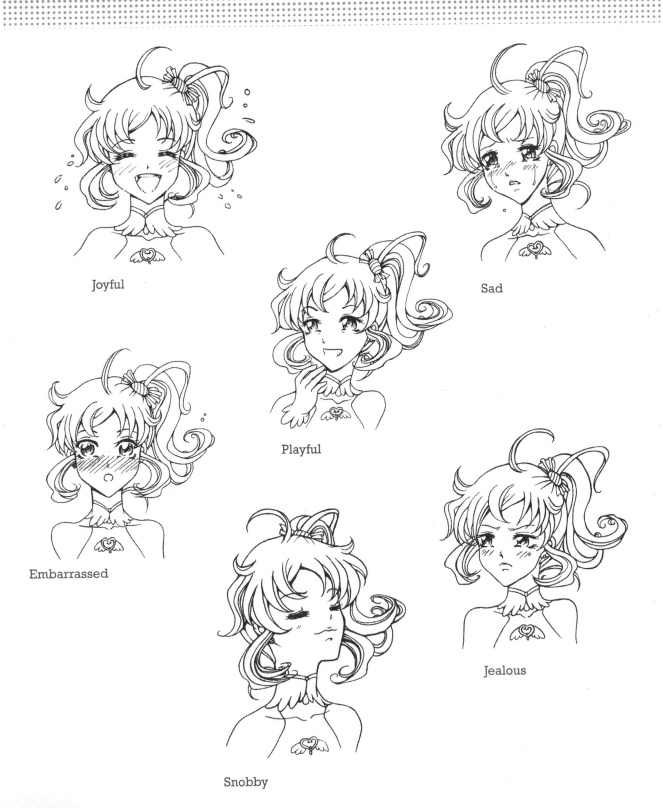

Joyful

Sad

Playful

Embarrassed

Jealous

Snobby

The Manga Mouth

When relaxed, manga mouths are made up of small lines. But when they react, they do so with big emotions. There are no wallflowers in manga! The mouth reflects this. Use the mouth to accentuate the expressions of your manga characters.

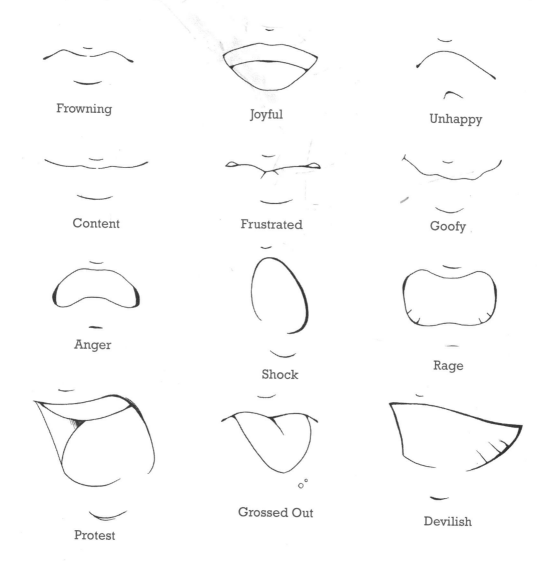

Frowning

Joyful

Unhappy

Content

Frustrated

Goofy

Anger

Shock

Rage

Protest

Grossed Out

Devilish

#3 Hair

Manga characters all have big hair. It's a hugely important element in every character's design. In fact, when properly rendered, it will add glamour and brilliance to your character. Styles can be graceful or cutting edge. Whatever the design, use it to make a statement.

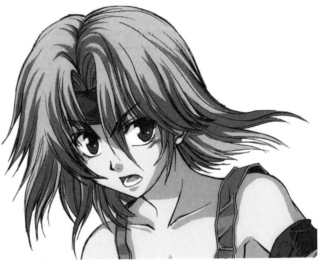

Rock-Star Hair

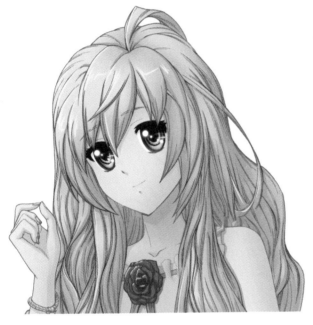

Long and Flowing

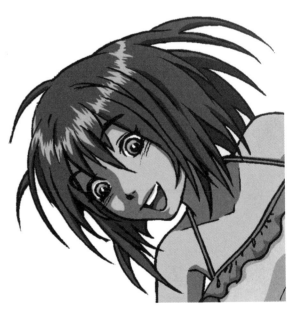

Short and Tousled

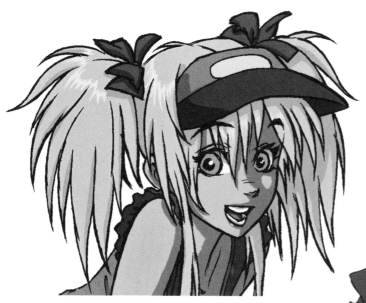

Wild Pigtails

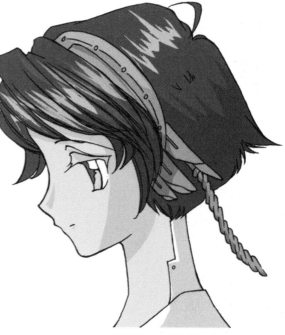

Sleek and Sweet

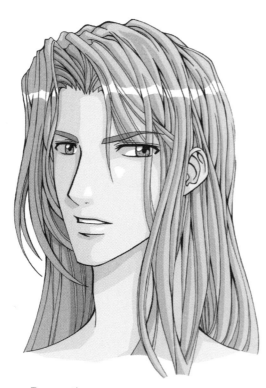

Romantic

Hair Shines

It's the hair shine—that white area—that gives manga hair its look of luster. There are two main ways to indicate it. In the first style, the highlight is drawn as a wave. In the second approach, the accent looks more like a lightning bolt. Both are effective; however, the wave is softer and more feminine. The lightning bolt is more dramatic and gives the character an added jolt of energy.

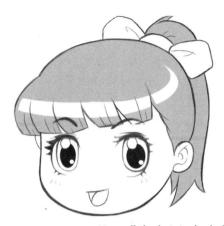

Here all the hair is shaded in with pencil, except for the shine.

There are certain circumstances when no highlight should appear. Spiked hair looks so much like a lightning bolt anyway that adding a jagged highlight would be over-kill. So no highlights are necessary.

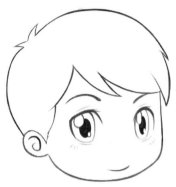

In a black-and-white picture, light hair frequently is given no shine at all, because this would require darkening everything around the shine, and the character wouldn't look blond anymore.

Black hair on boys shows the zigzag shines the best. This one is a horizontal lightning bolt, momentarily interrupted by the part.

When's the lightning bolt best?

The lightning-bolt hair shine works well when the hairstyle is parted in the middle.

Change the Hairstyle, Change the Character

While you cannot create an entirely new character simply by changing the hairstyle, the hairstyle is a part of the character's identity, and by altering the cut, shape, and length of the hair, you'll give yourself a head start in designing a new character. Hair color, realistic or fanciful, is also an important aspect in creating a character. By making a costume change and a few adjustments to the eyes, you'll add a new player to your cast.

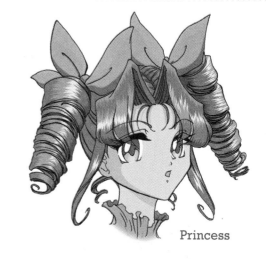

Princess

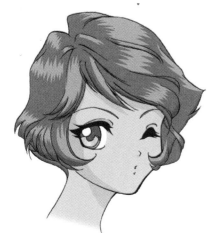

Trendy Teen

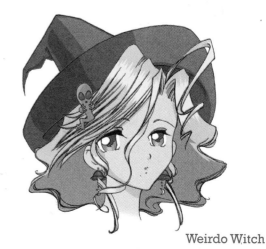

Weirdo Witch

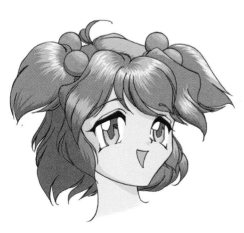

Fun-Loving Girl Next Door

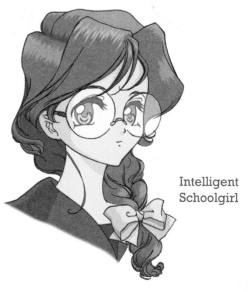

Intelligent Schoolgirl

#4 Body & Proportions

Many aspiring manga artists focus most of their time drawing faces and less time working on the body. This contributes to a lopsided skill level. Here are some essential pointers to get you started on the course to drawing bodies the right way. First, think about placing the legs unevenly in a pose, instead of symmetrically, and both in the same position.

This gives the pose added interest. Second, allow the torso to lean in one direction, and to be curved, so that it won't look flat and stiff. And third, work to create a natural pose in which the body looks relaxed, not tense. Treat the body as something that is flexible, not rigid, and you'll improve rapidly in this area.

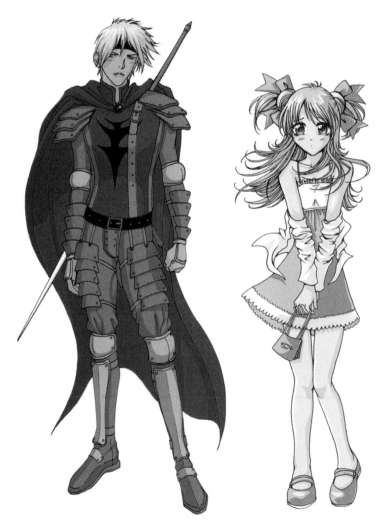

Front View

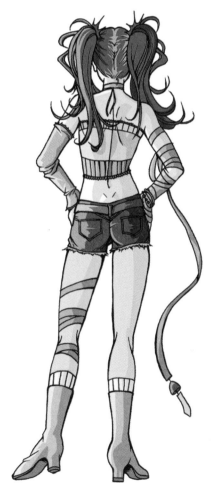

Back View

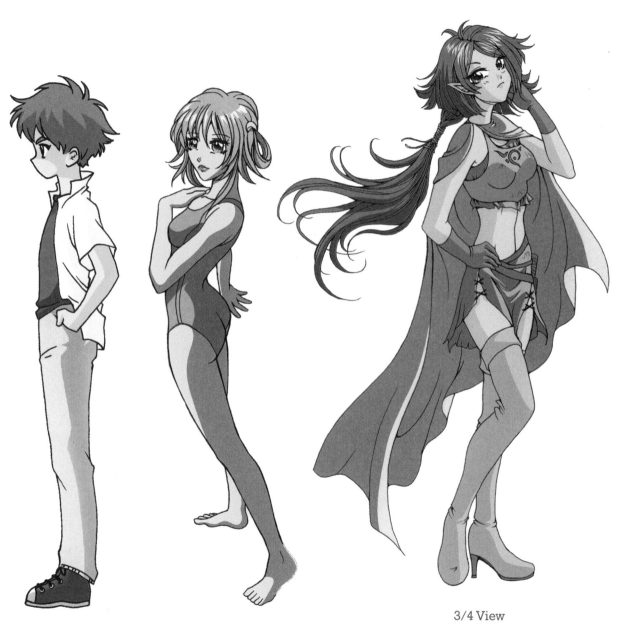

Side View

3/4 View

Regular Manga and Chibi: Height and Proportions

Different character types are different heights. As characters grow, they become taller, and their proportions change, as we'll see here. But this doesn't really occur with chibis—those super-cute characters manga fans love to draw. While they generally stay the same height, their body's proportions and their head and body shapes change.

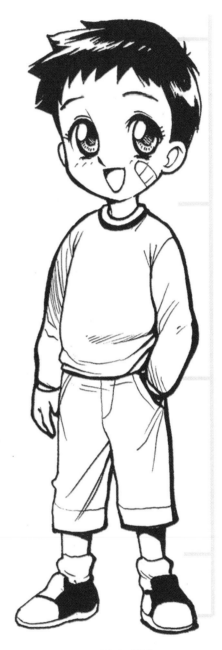

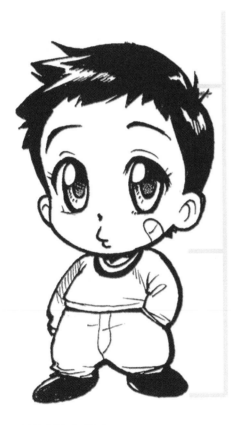

Chibi Little Kid
No matter what his age is, the chibi always remains a little over two-heads tall.

Regular Manga Little Kid
A regular-size manga kid is a little over three-heads tall.

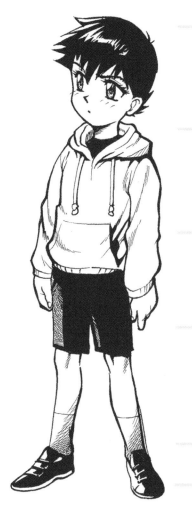

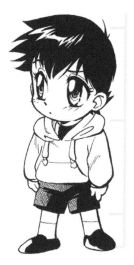

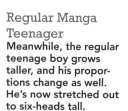

Chibi Tween
Even though he's taller than the little kid chibi, the tween chibi has the same proportions: A little over two-heads tall.

Regular Manga Teenager
Meanwhile, the regular teenage boy grows taller, and his proportions change as well. He's now stretched out to six-heads tall.

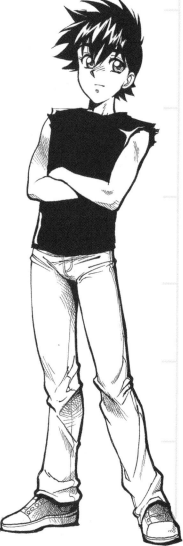

Regular Manga Tween
As the regular tween boy grows taller, his proportions change. He's now a little over four-heads tall.

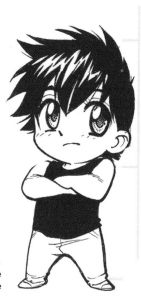

Chibi Teenager
The teenage chibi can't get any taller than the tween chibi, otherwise, he'll be too big. So his growth spurt stops there, and he retains the same proportions as all the other chibis: a little over two-heads tall. However, his face shape changes, and he even gets cute chibi muscles.

#5 Poses

There are many ways to portray an emotion through body language. But ultimately, the most important tool you have is your own gut instinct. After you rough out a drawing, pause a moment to see whether it conveys what you're trying to portray.

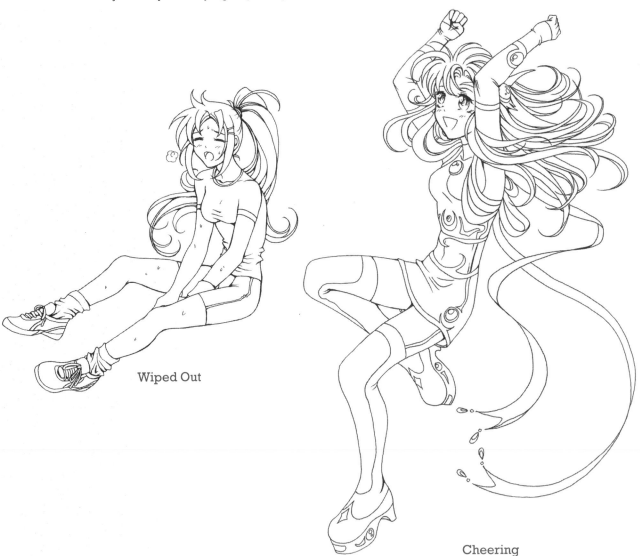

Wiped Out

Cheering

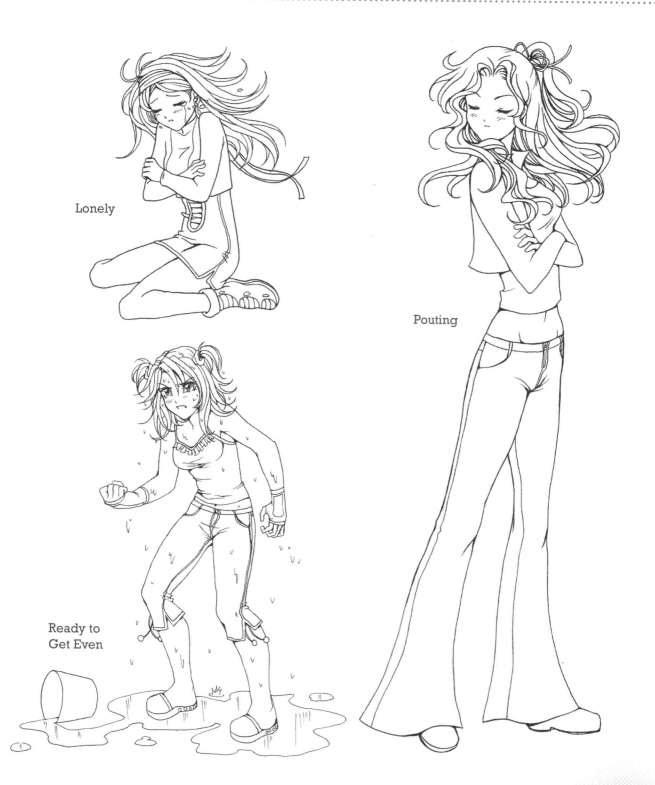

Lonely

Pouting

Ready to
Get Even

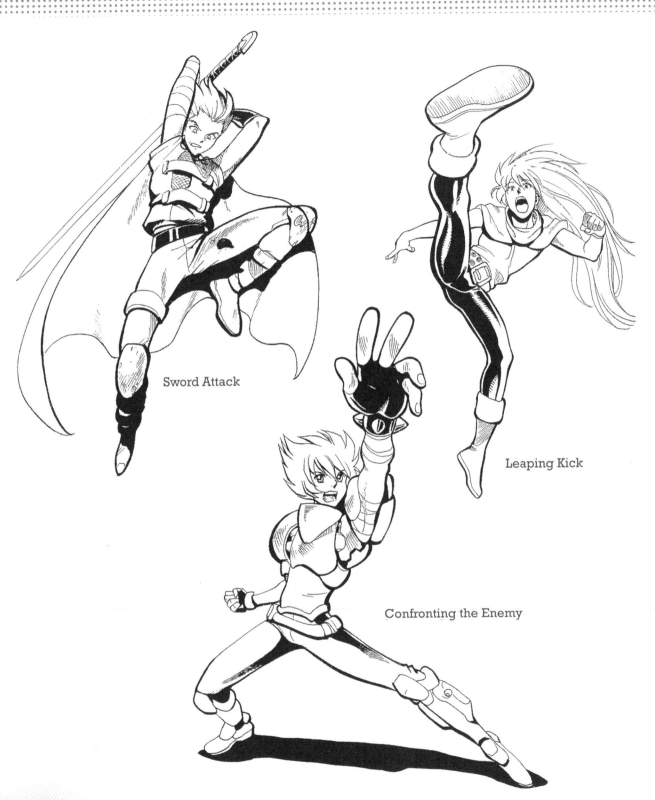

Sword Attack

Leaping Kick

Confronting the Enemy

#6 Outfits

Just as with hair, clothes can communicate a character's role. Take a look at these outfit examples and see what the details tell you about the characters. Some beginners struggle to design clothes for their characters, fearing that they may be overdoing it. It's actually as simple as selecting an outfit as if you were shopping for the character—with an unlimited budget!

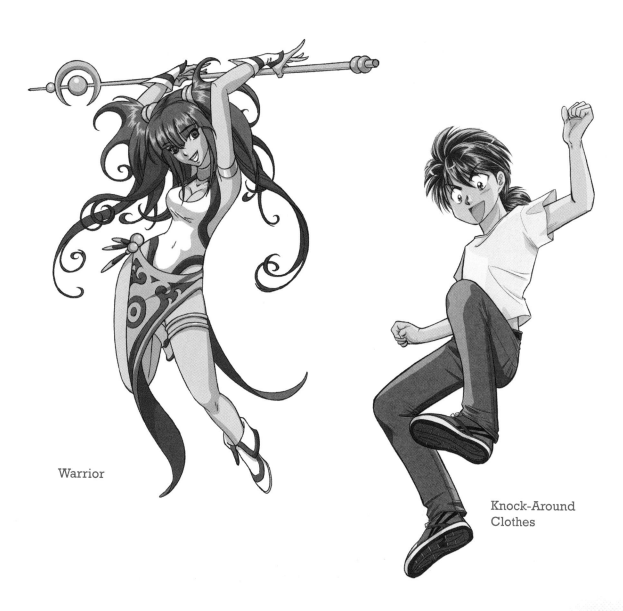

Warrior

Knock-Around Clothes

Trendy Student

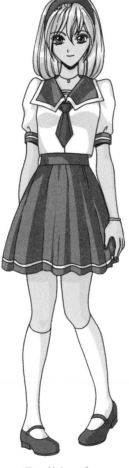

Traditional
Schoolgirl

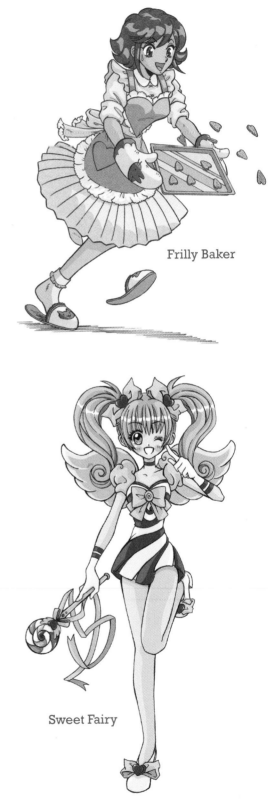

Frilly Baker

Sweet Fairy

Making Clothes Look Real

The body pulls and tugs against clothing whenever a character moves or bends. This results in folds and creases. Wrinkling at specific points in the fabric is what makes clothing look real and flexible. If nothing wrinkled, it would look like plastic. If you've been hesitant to tackle this part of drawing clothing and costumes, worry no longer. The concept is simple: The areas where the clothing *presses down* on the body should be *free* of wrinkles and creases (indicated by patches of gray). Creases generally radiate outward from those places where the surface of the clothes is in close contact with the surface of the body.

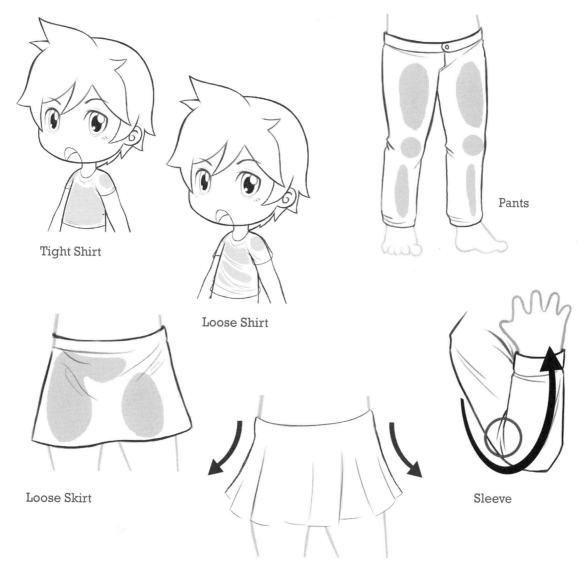

Tight Shirt

Loose Shirt

Pants

Loose Skirt

Pleated Skirt

Sleeve

#7 Character Types

You can make up any type of character from wherever your imagination leads you. However, if you're drawing a graphic novel, a comic, or a cartoon, it's important to ground it with some established character types, too. Here are some popular, recognizable ones. Note how the outfits help to define the characters.

Skater Dude

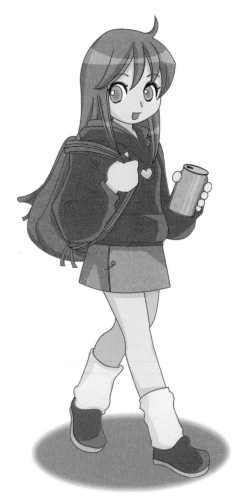

Kid Sister

Sci-Fi Fighter

Genius
Scientist

Martial Artist

#8 Mascots & Monsters

Some of the most inventive manga characters are the cute mascots and small monsters that serve as sidekicks to the main manga characters. Mascots tend to be based on actual animals, while monsters can come solely from your imagination (although they may have roots in dinosaurs, birds, and even sea life). Here are a few of both.

Mascots

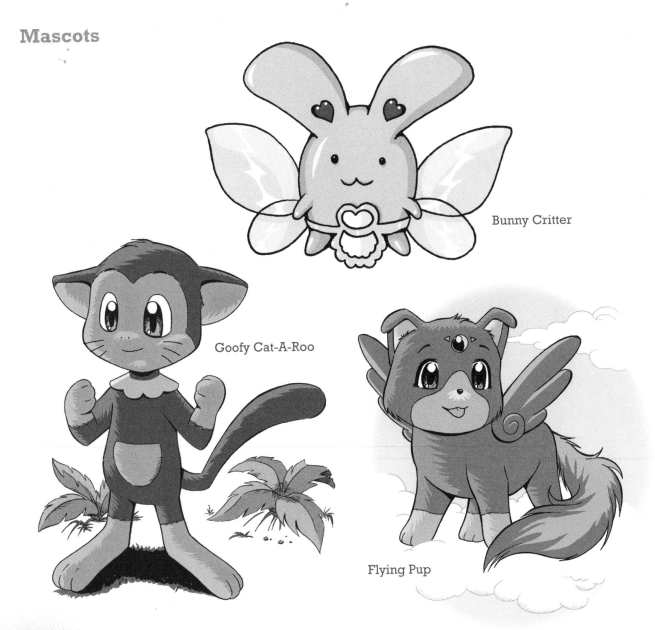

Bunny Critter

Goofy Cat-A-Roo

Flying Pup

Monsters

Fur Ball

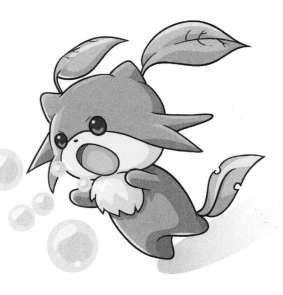

Leafy Monster

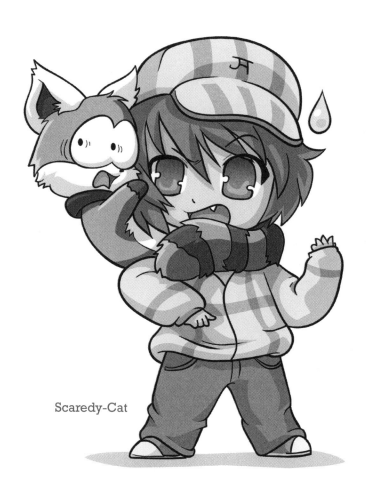

Scaredy-Cat

#9 Special Effects

There are as many types of magical effects as there are people with imaginations. Some have become so popular that they're eagerly anticipated by loyal readers. Let's put a few of them into your drawing arsenal.

Energy Waves

Commanding
the Sea

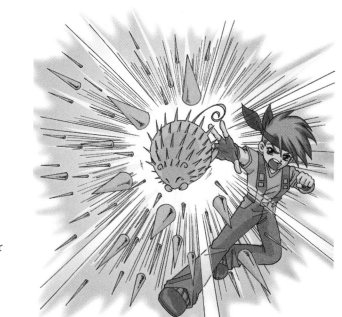

Spike Sprayer

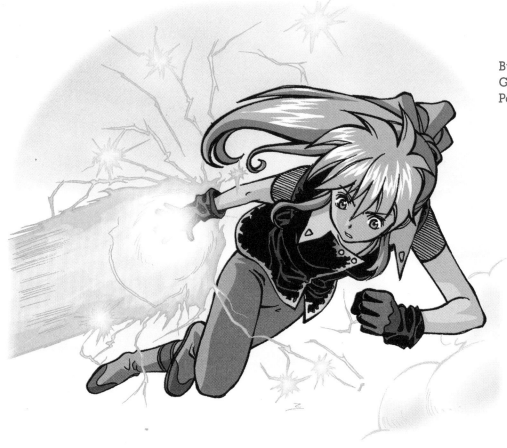

Burst of
Glowing
Power

#10 Cat-Girls

Cat-girls are everywhere—they appear in all genres and in a variety of roles. How could we leave them out of our top ten? We can't! So here are some popular versions for you to try.

Feline Cat-Girl

This cat-girl has evolved from the basic cat-girl. She is much more in the realm of feline. Her hair is longer, giving her an untamed look. Still, like all cat-girls, she has a pretty appearance and charming demeanor.

Basic Cat-Girl

At her most basic, the cat-girl has cat-ears and a tail on a pretty, human physique. She will often also wear arm-length gloves and leggings, covering up her cat-like furry patches and perhaps also hiding her paws and claws.

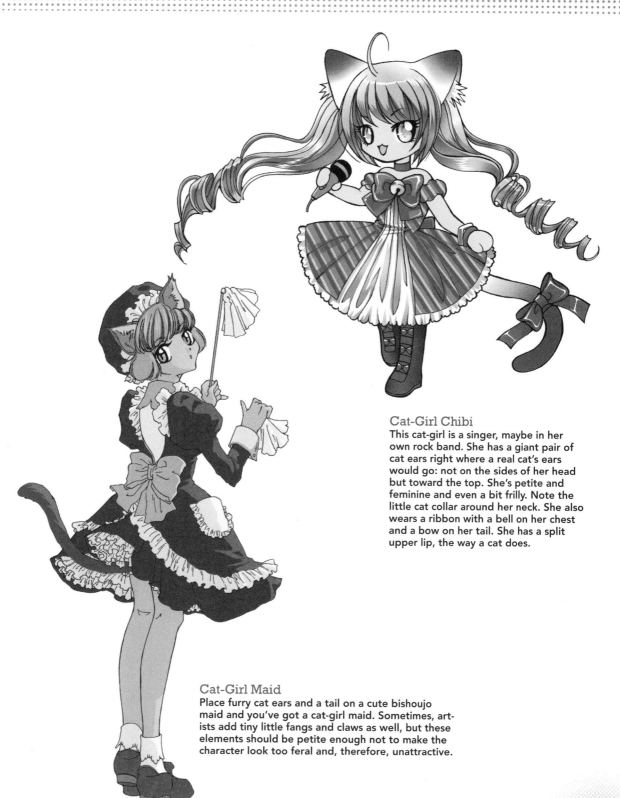

Cat-Girl Chibi

This cat-girl is a singer, maybe in her own rock band. She has a giant pair of cat ears right where a real cat's ears would go: not on the sides of her head but toward the top. She's petite and feminine and even a bit frilly. Note the little cat collar around her neck. She also wears a ribbon with a bell on her chest and a bow on her tail. She has a split upper lip, the way a cat does.

Cat-Girl Maid

Place furry cat ears and a tail on a cute bishoujo maid and you've got a cat-girl maid. Sometimes, artists add tiny little fangs and claws as well, but these elements should be petite enough not to make the character look too feral and, therefore, unattractive.

PART TWO
Let's Draw It

Classic Schoolgirl

The schoolgirl is one of the most popular manga characters, complete with school uniform. This is the classic schoolgirl uniform. You don't have to reinvent the wheel in order to come up with your own variations. Try adding different patterns to the skirt. Add oversized buttons and pockets to the sweater. Leggings could replace the knee-high socks shown here. A series of small changes can add up to a whole new look.

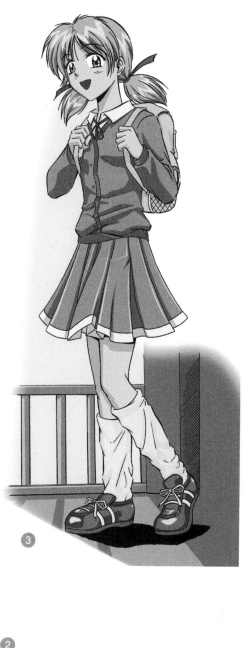

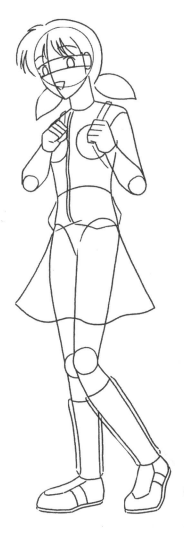

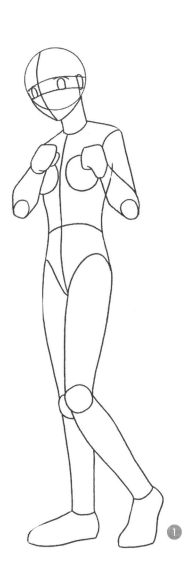

Chibi Schoolgirl

Even in the chibi subgenre, school adventures are at the center of some of the most popular manga graphic novels, so let's look at the chibi-size schoolgirl, as well.

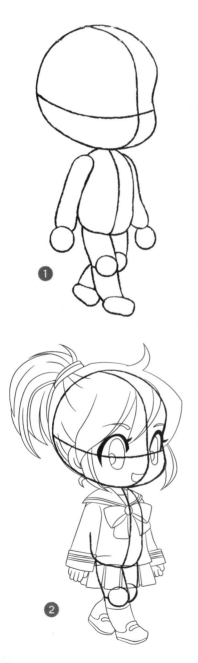

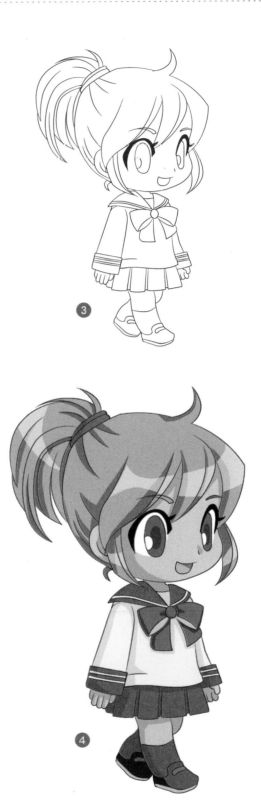

The Crush

Usually in manga stories in school settings, there's the crush—the boy who all the schoolgirls have crushes on and fight over. He's the one who can make the schoolgirl blush and forget what she was going to say. She's sure he likes someone else. And why shouldn't he? Every time he sees her, she trips, falls, or spills something on herself due to a case of nerves. When he stops to help her clean it up, she practically bursts into tears of embarrassment. And he can't understand why she never wants to talk to him!

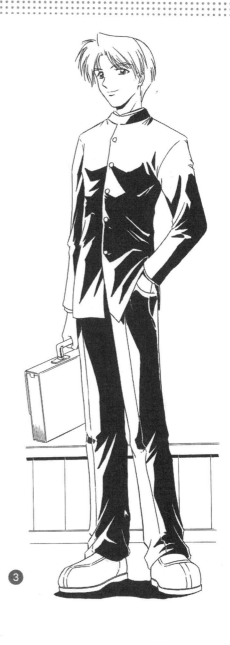

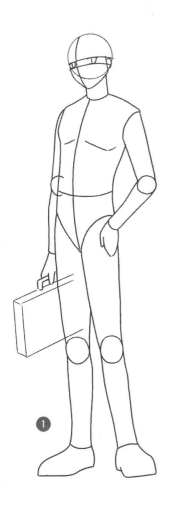

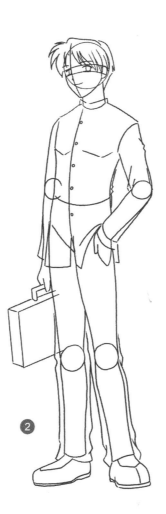

Cat-Girl Majorette

This high-steppin' cat-girl possesses the right cat "gear" to identify her as such. She's got cat ears, a cat tail, and a cat tooth for an accent. Note that it's only one cat tooth. Two cat teeth begin to look like fangs. And what's with the blue hair? Well, we don't really have to quibble about being realistic, do we? Remember that hair helps establish a character's identity. This girl's blue hair is a cute complement to her outfit, and helps tie her look together.

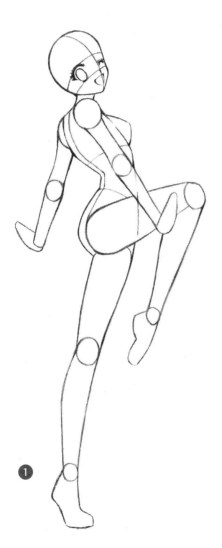

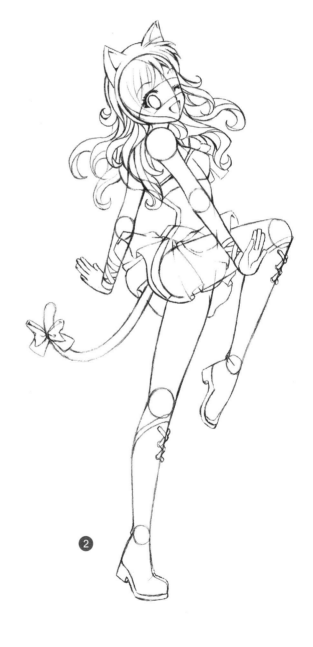

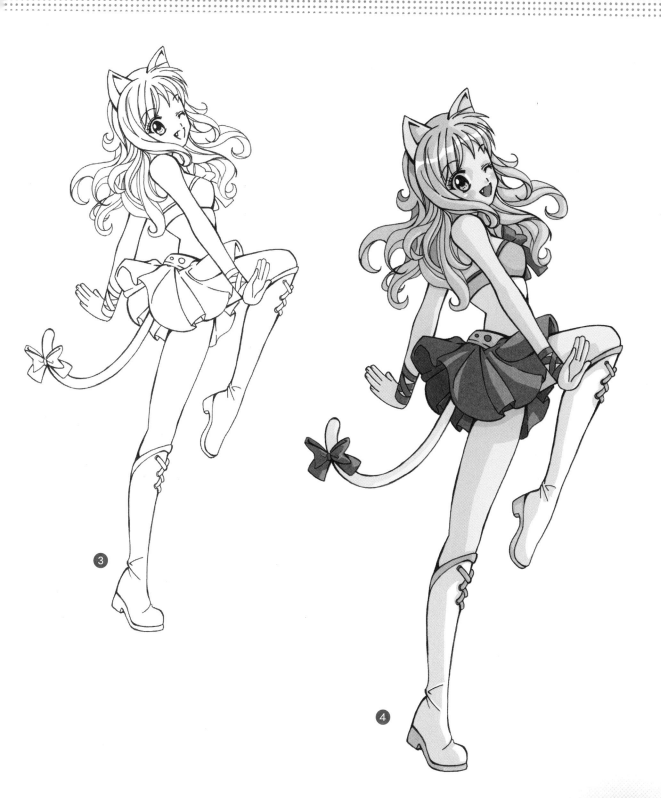

The Magical Girl

Magical girls are, typically, schoolgirls who are suddenly called upon to save another world that's in danger. To do this, they are given special powers that transform them into superidealized "magical" versions of themselves, sometimes still identified as schoolgirls (just more glamorized and amazing) and other times changed into fighters that don't retain that many schoolgirl elements. This magical girl fighter falls into this latter category. She can go after monsters that are twenty stories tall. That sword isn't just any sword, but a weapon imbued with supernatural qualities that can make her all but invincible.

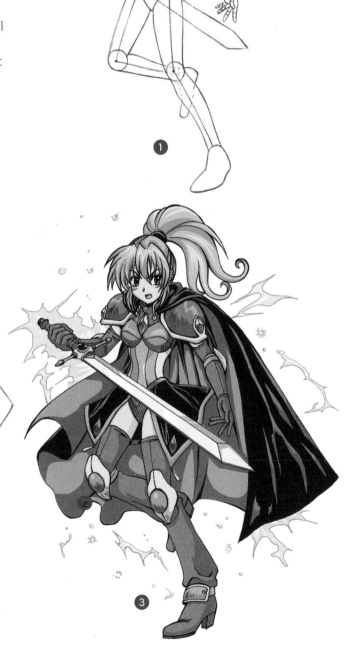

How to Show the Magical Girl Transformation

Now let's take a look at the actual basic steps involved in transforming from a regular girl into a magical girl. These steps may go in sequence, or they may be combined.

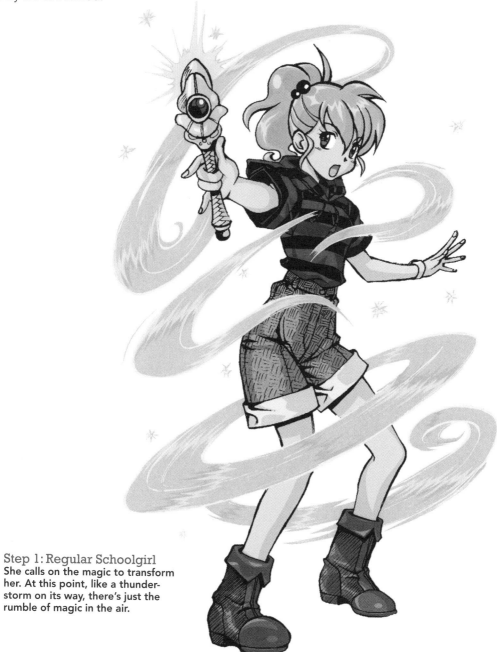

Step 1: Regular Schoolgirl
She calls on the magic to transform her. At this point, like a thunderstorm on its way, there's just the rumble of magic in the air.

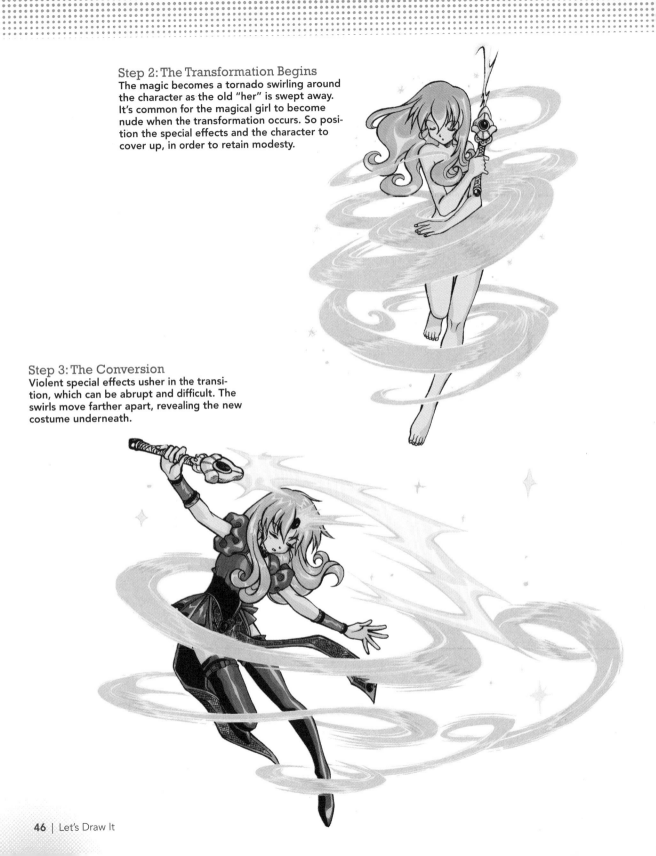

Step 2: The Transformation Begins

The magic becomes a tornado swirling around the character as the old "her" is swept away. It's common for the magical girl to become nude when the transformation occurs. So position the special effects and the character to cover up, in order to retain modesty.

Step 3: The Conversion

Violent special effects usher in the transition, which can be abrupt and difficult. The swirls move farther apart, revealing the new costume underneath.

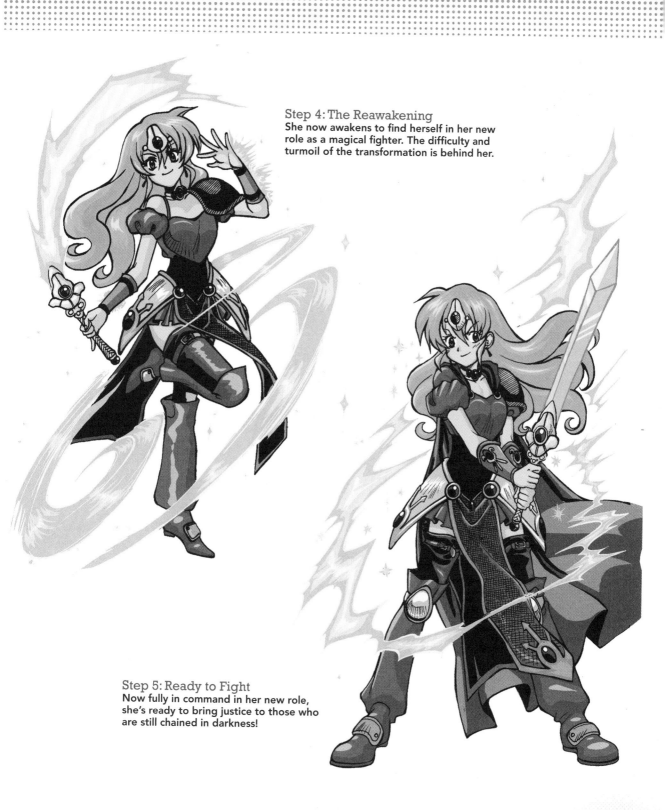

Step 4: The Reawakening
She now awakens to find herself in her new role as a magical fighter. The difficulty and turmoil of the transformation is behind her.

Step 5: Ready to Fight
Now fully in command in her new role, she's ready to bring justice to those who are still chained in darkness!

Sleepy Sidekick

This sleepy monster and his chibi are obviously working on two different schedules. The sweat drop by the little girl's head indicates maximum effort as she tries to roust this guy from his delicious slumber. Opposing intentions make comedy work. The chibi is cast as a type A personality, while the monster is a type B personality. Make that a type C!

These are about the upper limits of how big you can make your mini-monster before it starts to overpower a chibi friend and look, well, like a real monster. (You can make some bad-guy monsters a lot bigger, but then they'll look less "chibi-ish.") And notice the contrast: Big nose, little eyes. Big body, little legs. This kind of contrast can be funny.

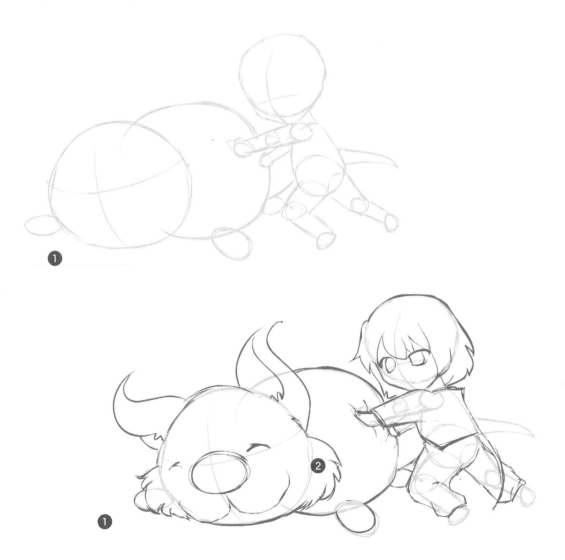

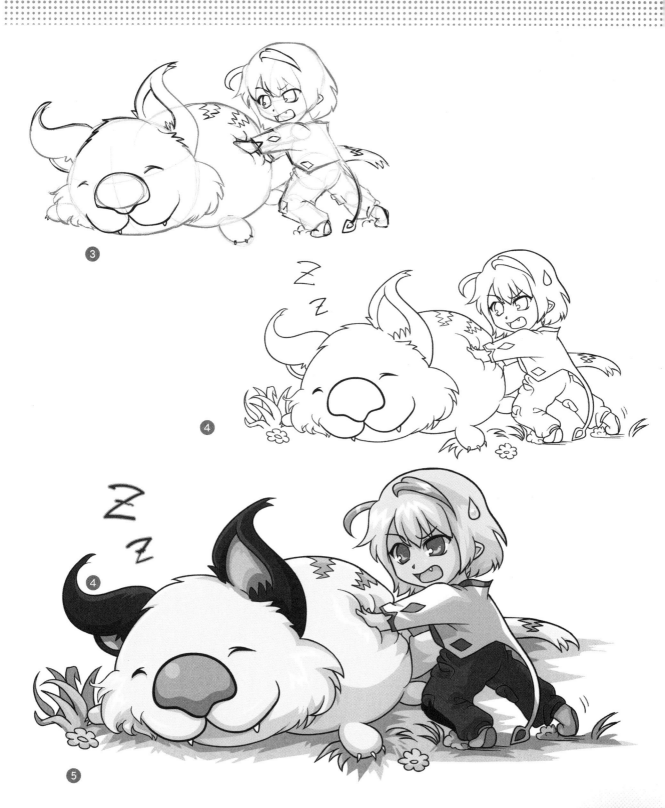

Chibi Monster with Magical Powers

Just because they're small, it doesn't mean they're not powerful. Chibi monsters are often the servants of their human owners in the same way that hawks were the trained servants of knights. The magical chibi possesses outsized powers, which can be used for good—or evil. You can usually tell if the chibi is good or not by the look of its owner.

Fire is always a good effect. The colors are brilliant, and they glow with intensity. But it's not enough to blow flames—that's been done since dragons have been around—you've got to dig a little deeper and get creative. This little creature, based on a dragon, can spew flames in any shape, virtually lassoing its opponent in a ring of fire. You've got to admire a bad guy who can do that.

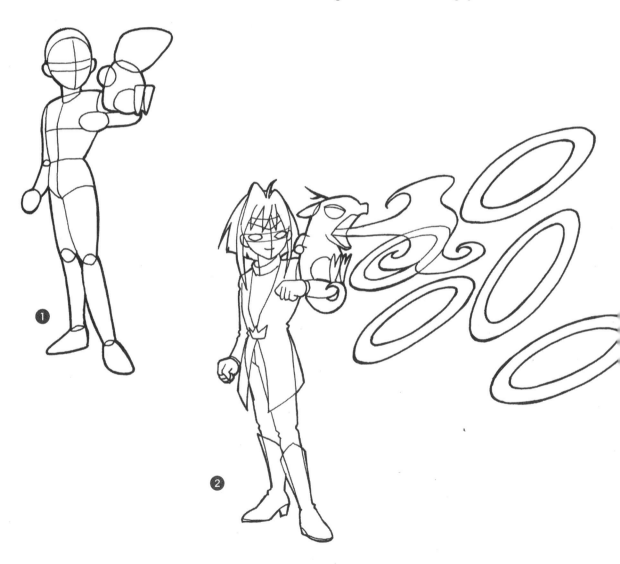

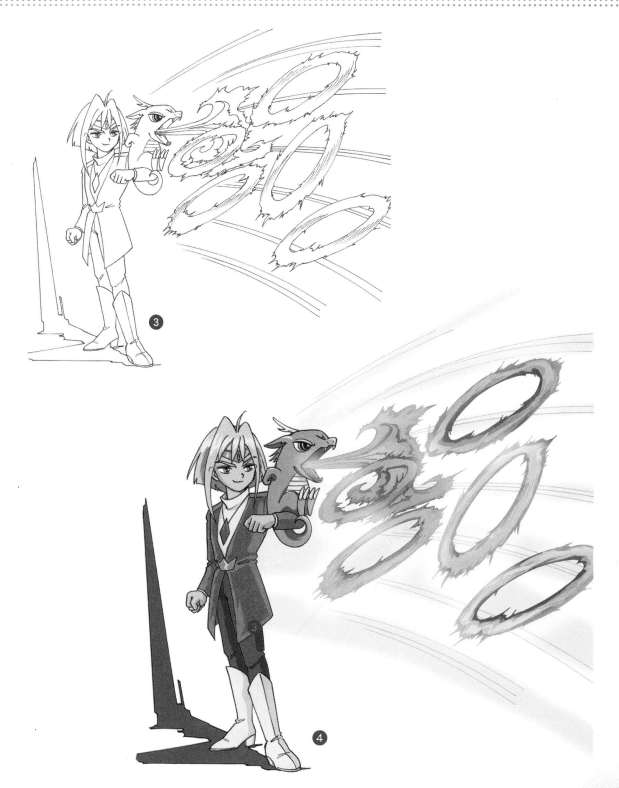

Young Sorcerer

A character will sometimes discover, quite by accident, that he has magical powers and, in so finding, realize that he's actually of a special lineage—for example, he's a sorcerer, a vampire, a shaman, an animal spirit, and so on. You can see in his expression that this young character is surprised to discover his magical abilities. This surprise adds a layer of depth to a scene. His hair goes crazy as his magical powers take effect, and his fingers are spread wide to convey a look of wonder.

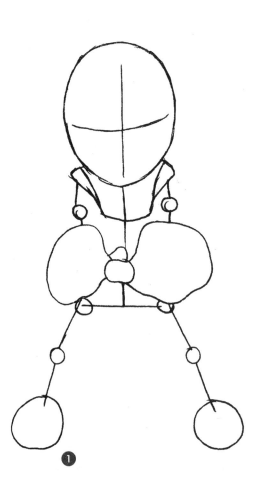

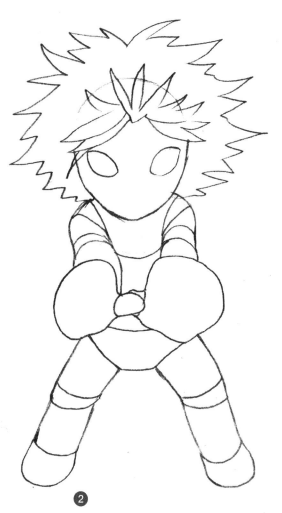

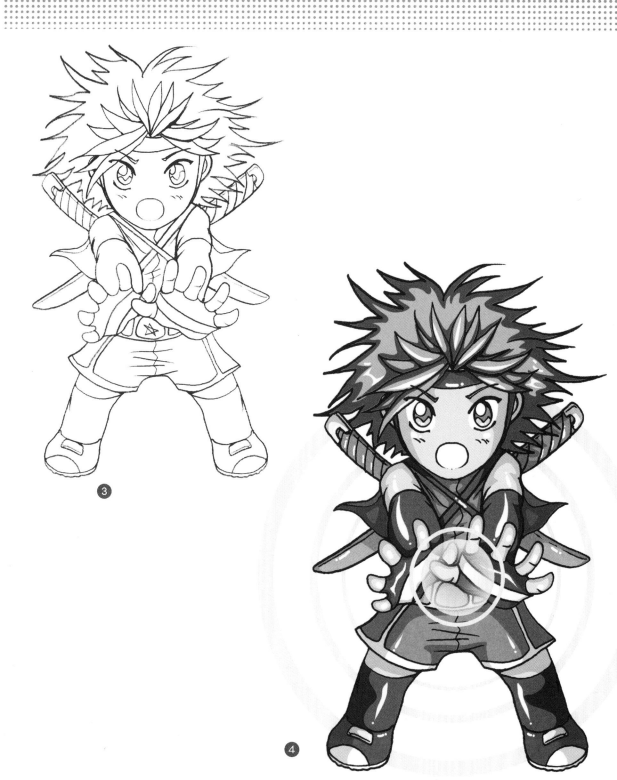

PART THREE
Let's Practice It

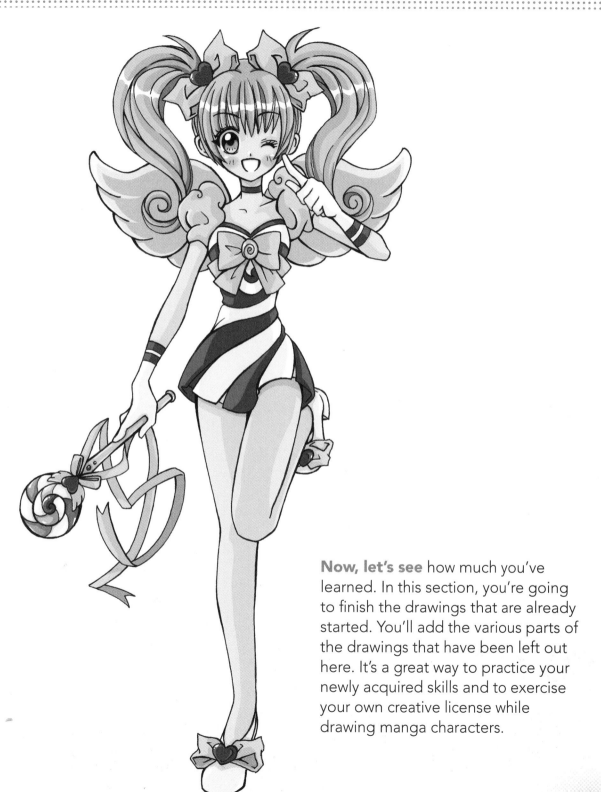

Now, let's see how much you've learned. In this section, you're going to finish the drawings that are already started. You'll add the various parts of the drawings that have been left out here. It's a great way to practice your newly acquired skills and to exercise your own creative license while drawing manga characters.

Try drawing a mouth to complete each set of eyes.

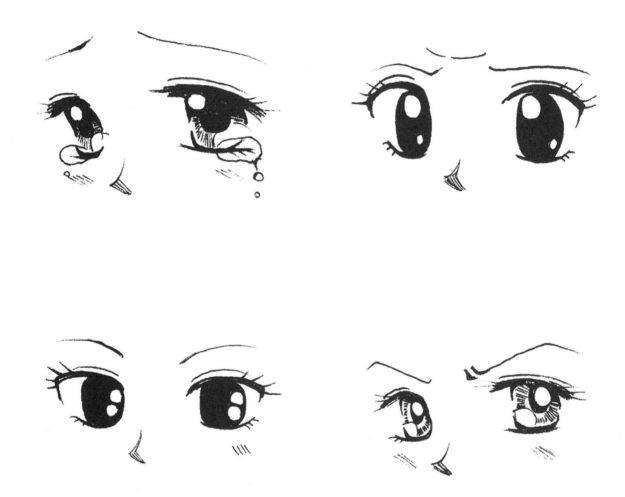

Give these characters a sad expression, a happy expression, and an excited expression.

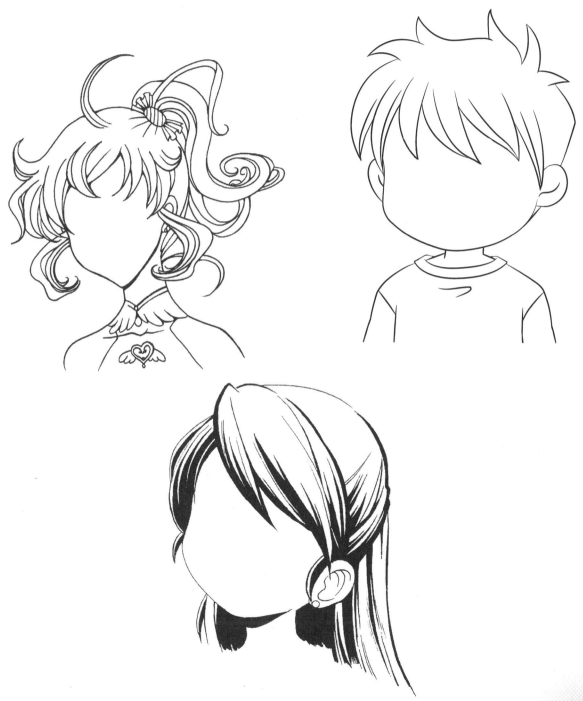

Give this boy a pose that matches his expression.

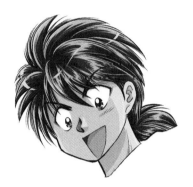

Finish the drawing of this schoolgirl.

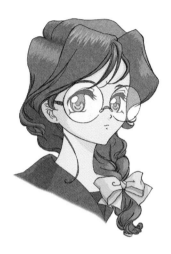

Draw the character this girl would turn into after undergoing a magical transformation.

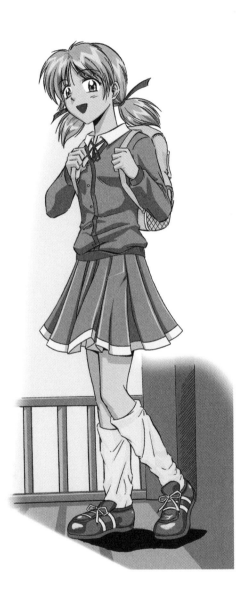

This cyborg character needs a mascot companion.
Draw one for her.

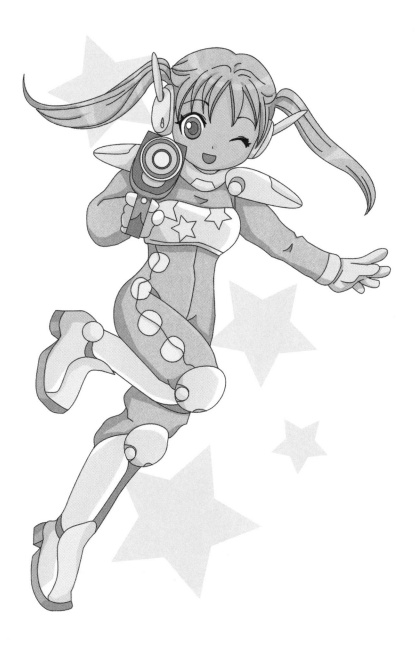

What is this chibi fighter's special power? Draw in the special effect he might create in a story.

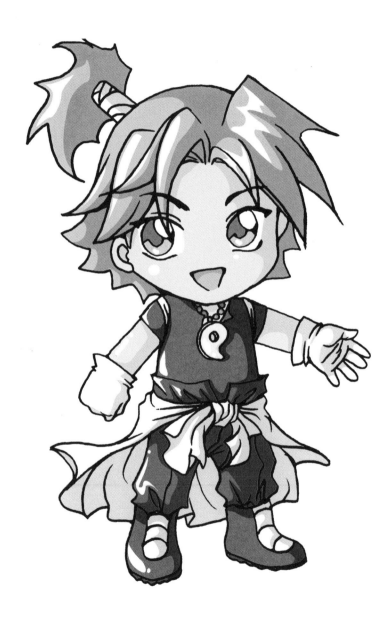

Can you turn this girl into a cat-girl? Try to finish drawing her body, as well.

Also available in *Christopher Hart's Draw Manga Now!* series